This publication is part of a series of products and publications.

Copyright 2016 Lynn Smith

ALL RIGHTS RESERVED. One or more global copyright treaties protect the information in this document.

This Special Report is not intended to provide exact details or advice.

This report is for informational purposes only.

Author reserves the right to make any changes necessary to maintain the integrity of the information held within.

This Special Report is not presented as legal or accounting advice.

All rights reserved, including the right of reproduction in whole or in part in any form.

No parts of this book may be reproduced in any form without written permission of the copyright owner.

NOTICE OF LIABILITY

In no event shall the author or the publisher be responsible or liable for any loss of profits or other commercial or personal damages, including but not limited to special incidental, consequential, or any other damages, in connection with or arising out of furnishing, performance or use of this book.

www.ingramcontent.com/pod-product-compliance
Lightning Source LLC
Chambersburg PA
CBHW080559190526
45169CB00007B/2827